FREELANCE WRITING QUICK TIPS FOR FAST SUCCESS

JOANNE MORRELL

First published in Australia 2020 with Sanguine Press

Copyright © Joanne Morrell 2020

The right of Joanne Morrell to be identified as Author of this work has been asserted by her in accordance with the Moral Right Act.

All rights reserved. No part of this book may be used or reproduced in any manner whatsoever without written permission except in the case of brief quotations embodied in critical articles and reviews.

Author Lining's books may be purchased for educational, business, or sales promotional use. For information, please email the sales team at joanne@hybridauthor.com.au

First Author Linings cover published 2020

FIRST EDITION

Designed by Jaz Harlow at www.dontlookdesign.com

ISBN 9780648595007

Also by Joanne Morrell
PRESENTED BY AUTHOR LININGS

Author Fears and How to Overcome Them

*This book is for all writers
who sought the courage
to be their own boss.*

Freelance Writing Quick Tips For Fast Success

This book is based on the author's personal experiences working as a freelance writer. It is not 'law', as such, in the way the freelance writing world works, but rather a snippet of useful information to help all freelance writers get ahead starting out.

Contents

About the Author	viii
Joanne Morrell	ix
Introduction	x
1. MINDSET	1
Create a Dream Board	7
Act Like a Freelancer	8
2. BUSINESS SET UP	13
Business Values	15
Choosing a Business Name	16
3. SERVICES	25
4. FREELANCE WRITING SERVICES	29
5. FREELANCE WRITING WORK	32
6. RATES OF PAY	36
7. FINDING FREELANCE WORK	43
8. Writer's Faith	52
9. Freelance Writer Traits to Succeed	53
The End	55
Author Fears and How to Overcome Them	56
Author Fears and How to Overcome Them	57
Acknowledgments	59
Freelance Writing Definitions	61
Index Pages	63

About the Author

Joanne Morrell is a Perth born and based writer and author in Western Australia, but grew up in a little fishing village off the east coast of Edinburgh in Scotland.

She is the founder of her local book club and loves story in all mediums: film, television, audio, digital and print.

Joanne is the host and creator of The HYBRID Author Podcast, interviewing industry professionals on how to have a career as a HYBRID Author both independently and traditionally publishing books. https://hybridauthor.com.au/podcast/

Setting up a freelance writing and editing business fresh out of university, Joanne worked directly with clients and swiftly learned some valuable lessons along the way. These are the tips she shares in this short, sharp snippet to help *you* succeed in your start-up freelance business.

Introduction

Freelance writing is many things to many people. At its core, it is showcasing you and your services to prospective clients in the hope of earning money for your written words. It can be challenging and frustrating at its worst, and interesting and liberating at its best.

With the digital nomadic lifestyle on the rise and people opting out of the conventional earning standards of the past, a brighter future working wherever, whenever and with whoever you want is now a viable option.

There has never been a better time to be a freelancer than today with more opportunities than ever, thanks to the internet. Companies require websites and an online presence if they wish to be successful in reaching their customers in today's market. Businesses and entrepreneurs (and freelancers) source other freelancers to do the jobs they can't. There is ample work to go around.

What This Book Is

Introduction

This book is for individuals starting a freelance business. I'm coming at it from a writing perspective as that's where my freelance expertise lies, but the information in this book can be applied to any artistic, editorial or journalistic freelance 'start-up' dealing with clients.

What This Book Isn't

This book is not a book on writing craft. It is not a 'get rich quick' book and it will not tell you how to source publication clients through magazines, newspapers and the like. However, it *will* tell you how to make yourself discoverable and work with customers in your local area.

What You'll Gain by Reading This Book

Investing an hour reading these pages will place you in the pro position before you've met with your first client. Had I known the contents of this book when I started out as a freelance writer, I'd have saved time, money and stress in discovering the little, (but important) factors previously unconsidered, having never launched a freelance business before.

This book is short and simple. The tips are quick and easy to follow. You can flick ahead to the section that interests you the most or you can read each page and answer the questions as you go along.

Fast success is at your fingertips.

So, let's get started.

1

MINDSET

THINK LIKE A FREELANCER

Well…how does a freelancer think?

After I graduated, I began applying for the kind of jobs from which I used to make a living; office work, retail, even hospitality. It was what I knew. Universities don't necessarily teach you how to shift your mindset to a self-starter one. I didn't feel qualified to apply for jobs that might use the knowledge I'd just obtained in my writing degree. I worried I might look like a fool, or worse, do a poor job. I had imposter syndrome and felt like a fraud for a few years.

And it really held me back!

. . .

The chapters in this book cover (what I believe to be) the key components to fast success in establishing a freelance writing start-up. *Mindset* is the first because it is important to have a helpful attitude when it comes to your writing and overall business performance.

Quick Tip 1
Believe in yourself and your abilities as a freelance writer

Whether you are starting at the very beginning of your freelance career or are mid-level, believing you can do the job will see you go far in this business. It's going to be hard at times. You might be new to the world of freelance, and the unknown can be a little daunting. But you can do this. You can do anything you set your mind to.

Quick Tip 2
Credit your credentials

If you have credentials, remind yourself why you are qualified to write. Read reviews of your work from past clients, teachers, peers, or fans (if any). Re read your writing and refresh the reasons why you wanted to become a freelance writer in the first place.

Questions

- What professional experience do you have?
- Have you completed any courses that credit you or your freelance business?

- Have you undertaken any writing work prior to freelancing?
- What do you believe is unique to the way you write?
- What personal training have you had?
- What personal experience will help you conduct your business?

Keep the answers to these questions in your line of sight as reference to those days where self-doubt creeps in.

REMEMBER!

The answers to these questions don't necessarily need to be writing-related. You could have taken business or customer service classes or possess strong presentation skills; anything contributing to your freelance business which makes you capable to carry out this work is a viable answer.

And if you aren't feeling confident in your abilities and struggle to respond to any of these questions, consider what you are going to do to gain experience in your field. Take a few short courses. Write a few articles for free to not only build a profile but to also 'puff up' your courage in the process!

Quick Tip 3
Identify your freelance fears and turn them into 'get ahead' goals

It's good for your focus to be on the positive aspects of you and your freelance business, but it's also necessary to address your concerns upfront.

- How do *you* define success?
- What are the things you believe might hold you back from becoming successful?
- What misgivings do you have regarding this type of work?
- How will you overcome these obstacles?

Example
Financial 'get ahead goals'

- Have savings in the bank as back up
- Offer more services (if qualified to do so) as supplemental income
- Work a weekly paid job until regular clients are established
- Offer products on top of services: books, courses or speaking gigs

REMEMBER!

There are solutions to every problem. Take the time to consider if you have uncertainties and come up with ways to work through them. Addressing these issues head on clears the path for you to

succeed. You're preparing ahead of time for the things that may hold you back in the future.

Quick Tip 4
Watch motivational videos

If you suffer from low self-esteem (as I have in the past), use free aids to help you overcome personal characteristics. I'm a fan of watching motivational videos online. They have them on almost every trait: belief, focus, negativity, self-doubt, success, abundance and grind. I just type in the one I'm struggling with the most and watch as many as I need until I feel pumped again.

Quick Tip 5
Affirm your desires

Affirmations are another great way to speak aloud your ambitions: I am successful. I am an amazingly fast writer. I am a millionaire. I am the best darn freelance writer there ever was. I am in demand.

Write down your affirmations. What are they?

- I am successful
- I am…
- I am…

Review and read these aloud each day until you can recite them by heart and believe them to be true.

Quick Tip 6
Visualise what you want to achieve in your mind

Visualisation is different from meditating. In meditation, you clear your mind and concentrate on the breath quieting your thoughts. Visualisation is imagining what you wish for with your eyes either open or closed.

Picture what want your future to look like.

Questions

- What do you want your life to be like?
- How has your freelance business been able to support this vision?
- What is most important to you running your freelance business?

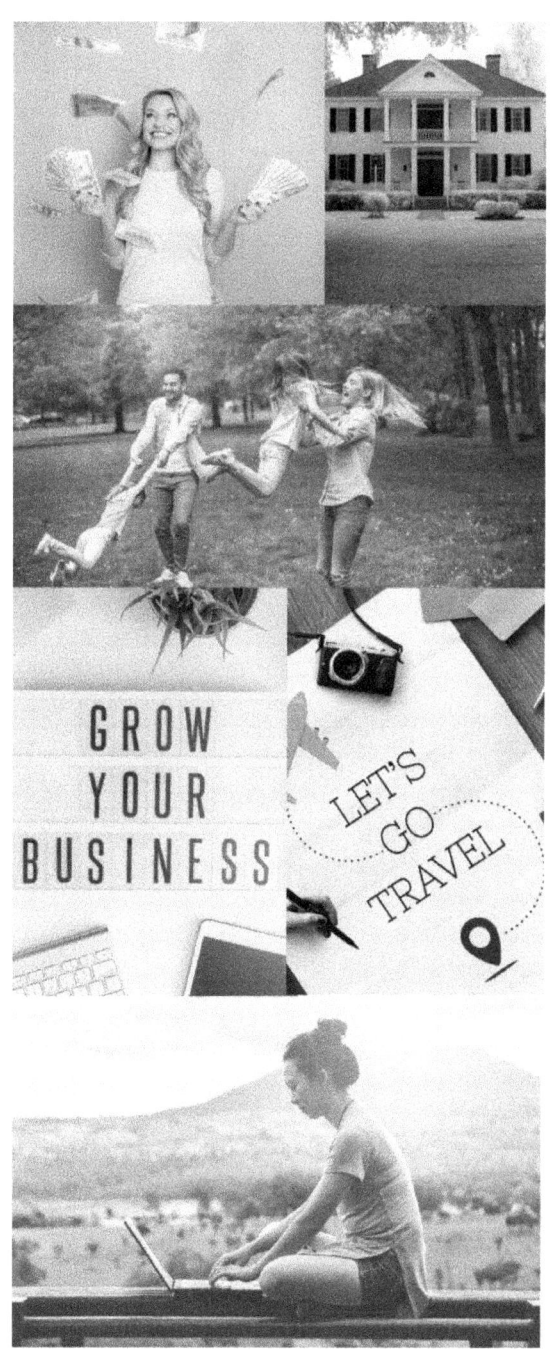

Quick Tip 7
Create a Dream Board

If you struggle to visualise without a physical presence, create a Dream Board from cut-outs of magazines or images you've found online – a snapshot of the goals you would like to achieve. Once you have made your board, spend a couple of minutes each day looking at it. Focus your thoughts on it.

The mind is your most powerful tool.

Use it to get what you want.

ACT LIKE A FREELANCER

How does a freelancer act?

A freelancer needs to have some level of confidence. In your business there's only you, no one else to hide behind. Inevitably, you will have to deal with people outside of email, whether that be in person, over the phone or through video media.

Quick Tip 8
Find your confidence or fake it

You can always pretend to be confident even if you don't feel like you are. The other person doesn't know how you are thinking and feeling inside, so be bold. Be brave. I strongly recommend working on becoming self-assured, as it will take you far in business and in life.

Quick Tip 9
Create positive working habits

If you had a regular job, most likely you would have had a daily routine; getting up at a certain time, eating breakfast and leaving the house to start work. You should apply the same habitual performance in your freelance career.

Getting the work done is the only way you are going to succeed.

Quick Tip 10
Schedule your time

Block out periods of your day to complete your freelance work and the jobs required to run your business, such as paperwork, marketing and website maintenance.

Quick Tip 11
Have realistic perspectives

Assess how long it takes you to complete projects, pieces or proposals, etc. Make sure you allow enough time for these projects and charge your clients accordingly.

Quick Tip 12
Play the long game

You've just started out in your freelance writing business. It's unlikely you're going to hit all your goals immediately. Or maybe you will! Who knows? But realistically, building a reputation and a business takes time.

Quick Tip 13
Learn to take the knocks and get back up again

Pitching your services and or ideas to other businesses or publications might not always land you a gig. Don't take it

personally. Keep putting yourself out there and more opportunities will arise.

Quick Tip 14
Get rid of 'the beginner' mindset

You might be a beginner at freelancing or a newbie business owner, but you're not a novice writer. You are a professional at your craft. There's an attitude circulating in the business world that as a beginner you should snap up any kind of work to get yourself going. Get rid of this notion immediately or else you'll end up with jobs degrading your worth.

I took a role writing for an E-cigarette review company when I first started out freelancing. An ex-smoker myself, I'm no stranger to E-cigs. Even following a brief and written example, it turns out E-cigs are complex. There are thousands of different types and models out there and if you are not overly-technically minded, the jargon can be quite confusing.

The assignment was a 2000-word article paying $40 with 48 hours in which to write it, along with five articles needing to be written overall – for a mere $40! A perfectionist at heart, researching, writing and editing the article took me a full day. After handing the article in, I received it back with further edits to complete. I quit then and there, realising this job was not financially rewarding for the time (my time) spent.

Where possible, try to avoid:

- accepting low paid jobs to get you started
- doing free work for clients
- writing for content mills

- believing you won't get any work focusing on one area of expertise

REMEMBER!

Just beware if you start out freelancing for free, clients might not expect to pay what you want later on.

Quick Tip 15
Practice makes perfect

The more you write and work and freelance, the more confident you will become inside and outside of your business.

Quick Tip 16
Be kind to yourself

Meet expectations with a realistic mindset and be kind to yourself.

*Believe that you have it,
and you have it.*

Latin Proverb

2

BUSINESS SET UP

BUILD YOUR BUSINESS EVERY DAY

Starting a business from scratch can be exciting and thanks to the internet, it's never been easier. There's lots to do and lots to consider.

REMEMBER!

If you're unsure of any of the abbreviations or unfamiliar business jargon used in this chapter, visit the index pages at the back of this book to learn the meanings of any unfamiliar words.

Business Values

. . .

If you haven't already done so, answer these questions:

- Why are you opening your business?
- What do you hope to achieve?
- What are your business goals?
- What do you and your business value?

REwrite Guru's
Core Values

Rewrite Guru

Helping companies and individuals to develop, create and communicate their mission and message effectively.

- What is your Mission Statement?

CHOOSING A BUSINESS NAME

It's important to pick the right name for your business. It can be on theme with your line of work or it can be catchy like the online gift and card company *Moon Pig*. Absolutely nothing to do with the business! It was simply the owner's nickname at school. And everyone remembers it because it's unique.

Quick Tip 17
Check the domain and social media handles are still available for the business name you've chosen and snap them up

This tip might appear obvious to some but if you choose a name already taken for either your website or social media channels, a lot of time, money and effort creating these pages will be wasted and you'll have to start again.

I thought I had secured *Rewrite* as my business name, but when it came time to launch, turns out I hadn't registered it. I 'settled' on *Rewrite Guru*, but I was never happy with that scenario. The point I'm making here is the moment you find a name that fits, and it's available, register it; no matter where you are in the process of starting up your business.

Quick Tip 18
Run a poll

If you're undecided on a name or are uncertain of the one you have chosen, run a poll through social media (if you have a presence) or amongst a circle of friends to gain feedback on which name people like the best.

REGISTER YOUR BUSINESS

Quick Tip 19
If you haven't registered your business, then quite simply, your business name doesn't belong to you (if in Australia)

An ABN is an Australian Business Number. Most likely, as a freelancer, you will be classified as self-employed – a sole trader – or you can set up your business as a company (Pty Ltd).

You will need an Australian Business Number to pay tax and GST, if applicable. You will also be required to supply your ABN to your clients.

REMEMBER!

Registering your business will vary depending on which country you reside in. Check with your country's taxation department regarding this process.

BUILD A WEBSITE

Quick Tip 20
Pay for private hosting

If you create your website through a free platform, you will not own your site. They will. They own the files and the website codes.

Your company may change direction in the future. Using a free site restricts the amount of traffic allowed to your page.

Paying for private hosting allows you to own your website outright.

Quick Tip 21

Consider if you will sell products as well as services from your website.

Merchandise, eBooks or courses are all a great way to supplement your freelance writing income.

SECURE SOCIAL MEDIA SITES

Quick Tip 22
Choose the social sites frequented by your target audience

There are hundreds of social media platforms with more and more popping up daily. Define who your target market is and investigate which demographic visits which social media platform and set up a space accordingly.

Quick Tip 23
Master one or two social media sites, then add more

It is better to utilise a couple of social media channels than to have an inactive profile across them all. Building a small but engaged audience is better than spreading yourself too thin.

Quick Tip 24
Target your dream clients

Social media is a great way to connect with people other than your intended audience. You can interact with your competitors and other like-minded entrepreneurs online and 'like' and 'follow' the companies or people for whom you'd love to freelance.

Questions

- Who would you most like to write for?
- Are there any individuals you would love to help spread their message by doing what you do?
- Are there any publications or companies where you'd love to lend your expertise?

Quick Tip 25
Network and make contacts

A lot of business is carried out through word of mouth. I've found (in Australia especially) it's *who* you know sometimes, not *what* you know. Turn up to events in your area, meet people and pass out your business cards. Be creative and have fun.

REMEMBER!

As a freelancer, your target market is going to depend on the type of services you provide as to who needs them and where they are based.

Quick Tip 26
Utilise local libraries

Your local library has a wealth of free knowledge on any topic: business, marketing, social media, website building. You can teach yourself just about any skill to get your freelance business started through free learning.

Quick Tip 27
Cutting costs

Some people save some money before going freelance; others just dive right in. If you're not a saver, looking at ways of adjusting your

lifestyle until your business grows might be beneficial until you're earning a regular income through repeated clients.

Quick Tip 28
Do business paperwork as soon as it arrives

Print and file bills, invoices and receipts as soon as you receive them. This will help you to stay on top of all-important paperwork, rather than leaving it until the last minute, letting it pile up and becoming a problem you definitely want to avoid.

Quick Tip 29
Train in the accounting software you choose

Decide if you are going to do your own books or hire a professional (possibly another freelancer) to do them for you. If you choose to do it yourself, I recommend investing in a proper accredited course for the software program you settle on to avoid forking out more fees and resulting in lost time down the track because your bookkeeping is incorrect. Again, you can find books to borrow from your local library on specific (and free) software.

REMEMBER!

Your time is precious. Take into consideration the loss of income if you choose to do your own taxes, rather than hire an expert who can take the pressure off at an affordable price, leaving you free to get on with earning an income by doing what you love, which is writing.

MARKETING MATTERS

Marketing is massive and has never been easier to learn. It's not enough to just make a website and sign up for a few social media channels and hope people will find you. It's important to let people know you are there.

Questions

- Who are your customers?
- Are they companies or individuals, or both?
- Where are they located?
- What age are they?
- Gender? (If any)
- How do they search for information?
- How can you reach them?
- How do your customers make purchases related to your services?
- What type of marketing are you going to focus on relating to your customers?

REMEMBER!

A lot of this information can be found online through market research or you can ask your specific age demographic how they make purchases, through search engines: the Yellow Pages? Word of mouth? Facebook etc? You need to do your research beforehand to decide where your marketing efforts are best spent. There's no point in running an advertisement in the newspaper if your clients look for local companies online.

Quick Tip 30
Connect your marketing efforts with the freelance services you offer

If you're a copywriter for social media, you can showcase your services via your own social media channels. The same goes with writing web pages. You can showcase your skills through your own website.

BLOGGING

If blogging is one of the services you provide, why not start your own business blog and blog about the other skills you offer? Blogging will showcase your style and set you up as an authoritative voice in your field at the same time.

BUSINESS BANK ACCOUNTS

Quick Tip 31
Set up a business bank account over an everyday account to receive benefits and points

Speak to your preferred banking provider about what accounts are on offer and decide what is right for your business. Most likely you don't need multiple accounts; just the one business account. Fees generally apply for business bank accounts but are usually tax deductible.

Speak to your accountant regarding this.

Starting out with an everyday account and switching over to a business one as your business grows is another way to proceed if you don't have any money to invest in a fee account at first. You can also choose a business account option that offers rewards and points incentives such as Frequent Flyer Miles.

BUSINESS TAX

Quick Tip 32
Find an accountant or lodge your tax return yourself

As a business, in Australia, you are expected to lodge an end of financial year tax return. You can either do this yourself online or you can go through a tax agent. Costs to pay someone else to do it are relatively low as a yearly fee. If tax returns, numbers and paperwork is your forte, then give it a go yourself and waive all third-party costs.

BUSINESS ACTIVITY STATEMENT (BAS)

In Australia, if your company is registered to pay goods and services tax (GST) you are required to submit a Business Activity Statement (BAS) every three months (quarterly) to the Australian Taxation Department.

To know more about GST see here: www.ato.gov.au/Business/GST/

To know more about BAS see here: www.ato.gov.au/Business/Business-activity-statements-(bas)/

REMEMBER!

You will need to refer to your own country's taxation department to learn what taxes your business is required to pay, by law. This is determined by your type of business (sole trader, partnership, Pty Ltd) and how much income you make and if you have employees.

Setting up a business is a lot to take in.

You're doing great.

*When everything feels like an uphill struggle,
think of the view from the top.*
Anonymous

3

SERVICES

WHAT TYPE OF SERVICES WILL YOU OFFER?

When I first started out as a freelance writer, editor and marketer, I wanted to provide as many services as I could. I thought this would provide me with more clients and more income. In hindsight, this is the case, although proposing too many services can be off-putting to potential customers.

Instead, focus on skills that complement one another, such as editing and marketing as well as writing. You might offer virtual assistance on top of your communication skills as a package deal for clients.

Depending on your target audience (business, individuals or both), you want your freelance services to solve a problem they are encountering. You want to do the jobs that hold client's back from their main work focus.

Questions

- What issues does your target market experience?
- How can your freelance business solve problems for your target audience?
- What are the benefits of your clients hiring your freelance skills?

CHOOSING YOUR SERVICES

Questions

- What are your main freelance skills?
- What have you been told you are good at?
- What style of writing do you want to build a reputation in?
- What area of writing have you had the most experience to date?
- Do any niche areas interest you specifically?

Quick Tip 33
Start small and work your way up

Master a few services you've chosen to offer and then turn your hand to another style of writing in which you'd like to build a market for your business.

Quick Tip 34
Research your competitors' skills

Browse the freelancers in your local area. Find out what skills they propose and see if there is a lack of services offered in a particular area of interest. This is what could set you apart from your competition.

Questions

- Who are your competitors?
- What services do they offer?
- What services don't they offer that you potentially could?

REMEMBER!

Local businesses might prefer to do business with local vendors. So, start there! Once you are established, you can throw the net to a wider (national and international) audience.

Quick Tip 35

Upsell your services

I hired the services of a professional graphic designer to create my company logo. After the job was complete, she mentioned she also creates websites. This was an upsell to the professional skills she'd already sold me.

Consider whether your clients can benefit from other services you provide.

4

FREELANCE WRITING SERVICES

There are many terms for services offered in the freelance writing world. Here is a brief list you can refer to anytime you come across these titles to help you express which of them you provide in short (approximate) detail.

Academic Writing
Scholarly-written assignments.

Article Writing
Newspapers, magazines, online providers.

Business Writing
Plans and white papers.

Content Marketing

Newsletters, SEO, social media, blogging, podcasting.

Copywriting
Advertisements, brochures, sales letters, web pages.

Editing Services
Copy edit, manuscript assessment, proofreading, substantive edit, content edit.

Essay Writing
Magazines, journals, scholarly publications.

Ghost Writing
Fiction, non-fiction, self-help, articles, educational publications, etc.

Online Writing
Articles, blogging, content/keywords, SEO, websites.

Press Release Writing
Newspapers, company and individual products.

Resume Writing
Curriculum Vitae.

. . .

Review Writing
Books, film, products, services.

Script Writing
Film, television, theatre and audio production.

Technical Writing
Grants, medical, scientific, manuals and eLearning modules.

REMEMBER!

See the index at the back of this book for definitions on the meanings of these industry words. I could never get my head around *copywriting* and the term *marketing*, for some reason. They don't seem to stick in my head. I look up these two words regularly to refresh their meaning.

5

FREELANCE WRITING WORK

As in any new profession, you're constantly learning as you go. Freelancing is no different. Originally, I thought I could just apply for any freelance writing job out there; and you can, but you'd be wise to consider these tips before doing so.

Quick Tip 36
Write in the fields you know

Be aware of the time it takes to write about a topic you don't know much about. Time is money and you will need to spend time researching an unknown topic. So, where possible, keep to those areas with which you are familiar.

Questions

- What subjects are knowledgeable to you?

- What are your interests, likes and dislikes?
- What makes you an authoritative voice in your field?

Scour the magazines at your local library or newsagents to get some idea of the different type of publications out there you can write for. Scan the online freelancing job boards for writing opportunities available and decide where your talents lie.

FIELDS OF INTEREST

Beauty, Beverages, Business, Computers, Craft, Entertainment, Finance, Food, Gaming, Health, Knitting, Motor Vehicles, Parenting, Sport, Weddings, Wellness and Wildlife.

There are hundreds more niche markets from which to choose.

Quick Tip 37
Make a wish list

Questions

- Who is your dream client or company to freelance for?
- Who comes second?
- Who comes third?
- How will you get noticed by this client or company?

Research and write out a plan of steps you need to take to score your desired freelancing clients and . . . don't hold back!

Quick Tip 38
Be honest about your skills

Don't offer services you aren't proficient in. You'll only tarnish your reputation by doing a poor job in an area you aren't confident just to earn a higher income. Stick with what you know until you grow in other areas.

Whatever you are, be a good one.

Abraham Lincoln

6

RATES OF PAY

KNOW YOUR WORTH

I found setting my rates to be one of the most delicate parts of my freelance writing career. Starting out feels like you need to undercharge. You don't.

PAYMENT OPTIONS

Per hour, per project, per word, per page. For instance, freelance writing jobs all differ in content and length. You would spend more time working on a full-length article than writing a short blog post, so charge accordingly.

Quick Tip 39
Talk fees with your local business centre

. . .

I visited my local business centre, which is situated in the University I attended, to discuss rates of pay and I got some great free feedback. If you don't have a business centre close by, a possibility might be to schedule a no charge consulting call over the phone.

Go online to find the local Business Association in your area. Libraries and community spaces are another great resource to possibly gain information on services to help you build your business services rates of pay knowledge.

Quick Tip 40
Snoop competitor prices

You need to do research to see what other freelance businesses in your local area are charging to set yourself up fairly in the market.

Questions

- What are the other freelancers in your area selling their services for?
- Are they underselling themselves or overselling?
- Can you see where you fit in amongst them?

REMEMBER!

. . .

It is very important to set your own rates based on what you offer and your experience in the field of freelance writing. You would be doing yourself a disservice by simply copying another freelancer's rates. Their experiences and the way they work are unique to them, just as yours are to you!

Quick Tip 41
Set your rates per industry standards

In Australia, many writers set their rates in accordance with the Australian Society of Authors (ASA) rates of pay. The ASA *'campaign at industry and government levels for author and illustrator rights including, but not limited to, robust copyright protections, fair contracts and fair pay. They set minimum recommended rates of pay for authors and illustrators.'* (This is a direct quote from the ASA website.)

Question

- Does your country have an institution such as the ASA that suggests freelance writing rates?

Quick Tip 42
Determine how long it will take you to complete the work

Nine times out of ten, clients will ask for a quote. At first, it's a little challenging to estimate how long a project will take, but it does get

easier as you gain experience. The more work you undertake, the more confident you will become in this area.

Questions

- Will you charge a research fee if approached to do work you are unfamiliar with?
- Will you charge for quick turnaround time?
- Will you charge for 'last minute' edits?

Quick Tip 43

Should you ask for half of your freelance fee upfront and half on completion of the commissioned work?

It is up to you how you manage this. Some freelancers complete the work and then ask for payment. Others ask for half now half later, and some ask for full payment up front. It's entirely up to you what you choose to do with your freelance writing business. You also need to determine the terms of payment (7 days, 14 days, 21 days).

Quick Tip 44

Decide if you accept shares in your client's company as payment for your freelance services

I once had a customer offer me shares in his company, as payment. He was working off estimates of figures he predicted the business would earn but wasn't even up and running.

If the company of the client you are dealing with is established and turning over a profit, shares aren't necessarily a bad thing. Always seek legal advice on this matter and make sure you gather as much information as you can about the business, before you commit to such an arrangement.

Quick Tip 45
Be aware different countries don't pay the same rates

There are many freelance writing gigs on the internet posted from various places across the world. Bear this in mind if you are contacted by an overseas client. Determine whether the expectation is for you to work according to their country's rates and not your own.

REMEMBER!
Don't be afraid to ask your worth. Believe in your skills and talents as a writer because if *you* don't, *who* will?

Quick Tip 46
Always ask yourself if it's worth your time
To quote for a freelance writing gig, there are a few things to consider:

- You're expected hourly rate
- How long the job will take you
- Who the client is

- How much they are willing to pay if counter offered
- Are you getting anything else out of it (if the fee is lower than your asking price)? Free advertising for your business perhaps? Or a trade swap?

Quick Tip 47
Raise your rates after you're established

Or before. It's okay to raise your rates whenever you like. It's your business after all. If you have too much work or feel you have reached another level within your expertise, then hike up your prices and don't feel bad!

This is how you make your living.

Go confidently in the direction of your dreams.
Live the life you have imagined.
Henry David Thoreau

7

FINDING FREELANCE WORK

Where do I start?

There are several ways to source freelance writing work through your own advertising efforts, such as a company website and social media channels to gain traction, job boards, publications, businesses and individuals requiring your services, as well as word of mouth.

Quick Tip 48
Job boards tend to advertise jobs on the lower end of the pay spectrum

It has been my experience scoring work through job sites, that the pay has been relatively low. They expect top notch work for a fraction of the cost.

. . .

Quick Tip 49

Make potential job connections through recommendations on LinkedIn

Social media site *LinkedIn* connects professionals and advertises paid work. If you are a freelancer, it's a great platform to join to network with like-minded people and industry professionals. It's who you know to gain word of mouth.

Quick Tip 50

Pitch your ideas to publishers

This is a skill you will particularly want to hone. The best times of the week to pitch to editors of magazines or newspapers, and the like, is from Tuesday-Thursday between 10:00am-2:00pm. You don't have to know a publisher to pitch them. Just keep it snappy, short and sweet and don't hound these very busy and overloaded people.

Quick Tip 51

Advertise your business, both online and offline

This comes back to the type of clientele you are looking to attract. Think of your local areas, high-end boutiques and establishments with money or the lesser earning income demographic with a bargain mentality. There is no right or wrong; only the type of customers you want to attract through your carefully thought-out marketing plan.

Questions

- Where might your target customers hang out?
- Where might they shop?
- How are you going to make them aware they need your services?
- Who are you competing against to get their business?

Quick Tip 52
Stay clear of content mills

Content mills are companies with an endless work supply. They expect you to pump out the content above average turnaround time for below minimum wage. This is slave labour at its best.

The one and only content mill I got caught in when I was a beginner freelancer was writing SEO and web copy for a marketing company. I was stoked to get taken on by them until about five jobs in. It didn't take long for the realisation to hit: I was never going to make any money going down that path!

Quick Tip 53
Circulate your local business associations to drum up local clientele

Almost every suburb has a local business association that has regular networking and business card sharing get-togethers. This is an extremely smart way to meet the local businesses in your area and let them know about your freelance services.

WORKING WITH CLIENTS

Before I set up as a freelance writer, I had never conducted any business meetings before. I was caught off guard by a few obvious things when one of *REwrite Guru*'s first clients wanted to meet face to face.

Quick Tip 54
Decide your availability to meet with clients

Where possible, choose the days and times that work best for you and display them in your contact information on your website and social media pages, so people are aware prior to booking a meeting. On the other hand, you will need to show flexibility and, where possible, fit in with your client's schedules.

Quick Tip 55
Work out a good halfway meeting point between you and your potential client

You should possibly check out a few places for regular business meetings beforehand to discover if they are suitable to conduct your

get-together.

Questions

- Is the place too noisy?
- Does it get crowded?
- Is it open at the time you agreed to meet your customer?
- Does it provide the relaxed atmosphere you were hoping for?
- How far are you willing to travel to meet with a client, taking fuel and your time into consideration?

Places to meet can include, cafes, libraries, shared working spaces or home offices.

Quick Tip 56
Buy your client a beverage (not the other way around)

I believe it is good manners and good business practice to offer your potential client a beverage, if meeting in a venue that provides drinks. If they have arrived before you and have already ordered one, you can ask them if they would like anything else. Decline their offer to buy you anything – always.

Quick Tip 57
Prepare written material and the questions you have for your client beforehand

. . .

You should generally know before your business meeting what your client wants from you or is proposing. Have the questions you need to know on hand and have the client fill them out. Go over them together, in case of 'dodgy' handwriting, so you are clear and decided on what is expected of you.

Questions

- What is the freelance service your client is seeking?
- What is the work intended for?
- What style of writing are they after?
- What tone do they want the writing to be in?
- What is the length?
- What date would they like the work started and completed by?
- Is there any feedback or edits on the work?

There's nothing wrong with being organised and having paperwork ready to support your cause, whether that be a portfolio, credentials, past work history or terms and conditions paperwork, as well as signed confidentiality agreements. Being prepared will save you time.

Quick Tip 58
Showcase any other services that might benefit your potential client

. . .

As discussed in the previous chapter services, before your business meeting think about what other skills you provide that might benefit your client on top of what they already seek from you.

I recently met with a client who wanted some documents rewritten. I told this client about the media kit service I provided. I could rewrite and contain all his documents in PDF format specifically designed with his business in mind as another option to powerfully deliver his message to his potential clients.

Quick Tip 59
All clients work differently

It's up to you, the freelancer, to take charge of the way you work. When I met with my first client, it became clear he was very 'hands on'. He called me a lot and wanted to meet all the time. He was giving me direction. Not the other way around.

I tried to work with the next client in the same way I had done with the first, asking him for his input, which only made him annoyed. It was the complete reverse; he wanted me to do the work and leave him be.

Two things clicked for me after these experiences; I needed to figure out how I conducted business and then take the lead. In general, your clients will seek direction from you, not the other way around. This will help to ensure that work is carried out on your terms, where practicable.

Quick Tip 60
Act like a pro from the go

When I first started freelancing, I felt the need to tell people I was new to business. I think this is because I am an honest, upfront person. But the reality is that nobody needs to know how long you've been around. Skip the 'I'm starting out' phrase and *act like a pro from the go*! You are (as I said before) a beginner in business not a beginner in writing.

REMEMBER!

Business etiquette is really 'a thing'. Having manners in business goes a long way.

BUILDING A REPUTATION

Quick Tip 61
Collect reviews from your clients

Asking your customers for a review is always a great idea, especially at the beginning of your freelance writing career. This will build your confidence and your reputation to solidify future working relationships.

*You never know what you
can do till you try.
Proverb*

8

Writer's Faith

What is writer's faith? Well, faith is loyalty and belief to a person, idea or thing and a writer is someone who writes, especially as an occupation. Put the two together and you have writer's faith. It's exactly as it sounds and is made up of these four things:

- Believing in yourself as a writer
- Believing in your writing abilities
- Having faith you will conquer your writing dreams
- Having faith writing is the right path for you

It's a kind of magic you will need to draw on every time you get that heavy rejection letter or email or phone call to say, *no thanks, maybe next time*. Or that negativity from another or from yourself that you're no good; that you're wasting your time. It is a superpower, so believe in it and use it to discover more about yourself than you ever knew existed.

9

Freelance Writer Traits to Succeed

Determination: to reach your goals (even if they feel out of reach).

Consistency: in your work, in your marketing and in your brand.

Competence: the ability to produce work of the highest quality.

Confidence: in yourself, in your abilities, in your business and in your dreams.

Professionalism: hold yourself in high regard and set a standard for yourself and others.

*What appears to be the end
may really be a new beginning.*
Anonymous

The End

Congratulations, you have reached the end of this book. However, it is only the beginning of *your* writing career!

If you enjoyed this experience and found my tips and expertise to be useful, head on over to the HYBRID Author website to claim your FREE Author Pass or FREE Freelance Writing Document Templates at www.hybridauthor.com.au

It's bye for now.

PRESENTED BY
Author Linings

Author Fears and how to Overcome Them

Joanne Morrell

Author Fears and How to Overcome Them

How many times have you said 'your writing's crap' or shied away from calling yourself an author?

Take comfort in knowing your author fears are valid, other writers feel the same way you do but are not letting fear stop them from putting themselves out there.

We are all feeling the fear, but doing what we love anyway.

It's your turn now.

Read on over at:
hybridauthor.com.au/author-fears-and-how-to-overcome-them/

Acknowledgments

I'd like to thank my mum and dad for always guiding me.

My husband for supporting my creativity.

My children for inspiring me.

The Author Linings freelance team: editor Wendy Macdougall from Text Perfection who makes my books shine and cover designer Jaz Harlow for her quality work in bringing my visions to life.

Also, many thanks to my lecturers and writing mentors at Edith Cowan University (ECU). In particular, Josephine Taylor: author of the contemporary, historical, fiction novel, *Eye of a Rook*; thank you for helping me advance in my writing career through sound advice and letters of recommendation.

To the clients who hired my freelance writing services when I was first starting out in my own business.

And, to the buyers of this book … without you my words would never be heard.

I hope these tips serve you well on your freelance writing and author adventure.

Freelance Writing Definitions

Academic writing: intellectual writing for educational purposes.

Article writing: short or long pieces intended for publication in digital and print newspapers, magazines, business and individual purposes.

Business writer: an individual who writes plans and proposals for companies.

Copywriting: writing copy for advertisements or publicity releases.

Copy Editor: book editor who specialises in copyediting.

Content writing: content written mainly for the web.

Content marketer: a person who focuses on using marketing to create, publish and distribute content.

Freelance Writing Definitions

Editor: an individual who revises works of writing for functionality purposes, spelling and grammatical errors for better readability.

Essay writing: an individual who writes of essays for publication.

Ghost writing: an individual who writes for another seeking no recognition for the work except payment.

Press Release writer: writes a press release, which is an official announcement (written or recorded) that an organisation issues to the news media, and beyond.

Resume writing: writing resumes for individuals for employment purposes.

Review writing: critical writing of products and entertainment for publication purposes.

Script writing: writing screenplays or scripts for television, theatres or movie-length features as well as audio production.

Technical writing: writing with the purpose of ascertaining funding (grants) and instructional manuals for businesses and or technical writing in the educational, medical, mining and scientific fields.

Index Pages

BUSINESS JARGON

Advertising: to give information to the public about (something) Macquarie Dictionary definition).

ABN: abbreviation for Australian Business Number.

B2B: shorthand for Business to Business sales rather than dealing with individuals.

B2C: abbreviation relating to Business to Customer sales.

BAS: abbreviation for Business Activity Statement.
 'If you are a business registered for GST you will need to lodge a Business Activity Statement (BAS).'
 www.ato.gov.au

Business: the sale of goods and services for the purpose of making a profit (Macquarie Dictionary definition).

Index Pages

Clientele: the customers/clients of a business person (Macquarie Dictionary definition).

Content Mills: freelance writing slang term referring to companies that offer dismal pay for web content, whilst making a high profit for themselves.

Domain: web address.

Freelance: a journalist, commercial artist, editor etc., who does not work on a regular salaried basis for any one employer.

Marketing: the act of buying or selling in a market (Macquarie Dictionary definition).

Mindset: positive mental attitude.

Mission Statement: purpose of why your business exists for employees and customers.

Niche: designed for a specific niche market.

Services: the supplying or supplier of any articles, commodities, activities, etc., required or demanded.

Social Media: online social networks used as media platforms, characterised by the dissemination of information through online social interaction (Macquarie Dictionary definition).

Trade swap: an exchange of services working as payment.

Target Audience: the people who are most suited for sale of your product or service.

Target Market: a group of individuals most likely to buy your product or service.

Values: measure of that quality which makes something esteemed, desirable, or useful: merit, worth. (Macquarie Dictionary definition).

www.ingramcontent.com/pod-product-compliance
Lightning Source LLC
Chambersburg PA
CBHW040743020526
44107CB00084B/2862